This Book Belongs To:

Copyright © Kreative Kolor - All Rights Reserved

No part of this publication may be reproduced, stored in a retrieval system, or transmitted in any form or by any means, electronic, mechanical, photocopying, recording or otherwise, without the prior written permission of the publisher.

COLOR TESTER

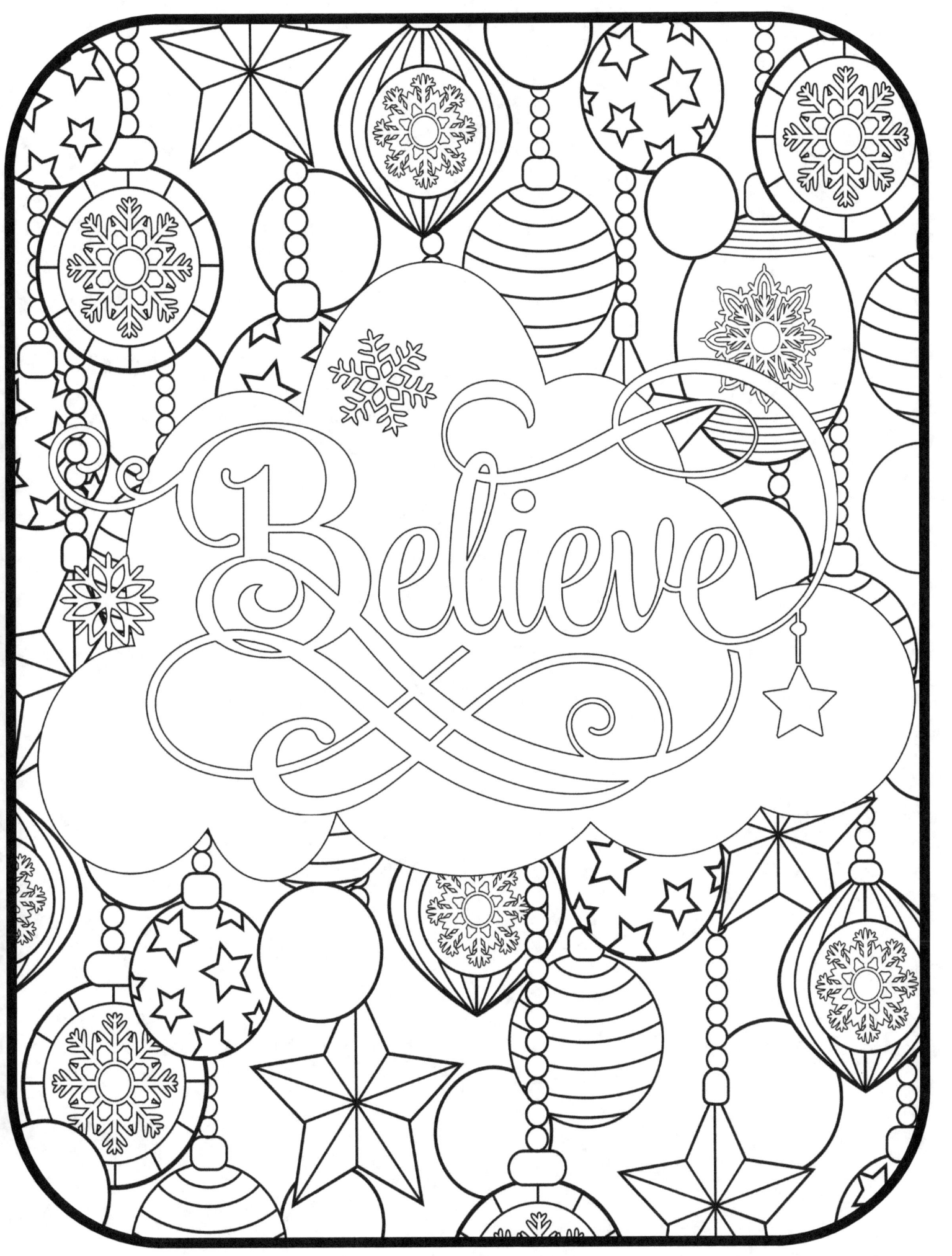

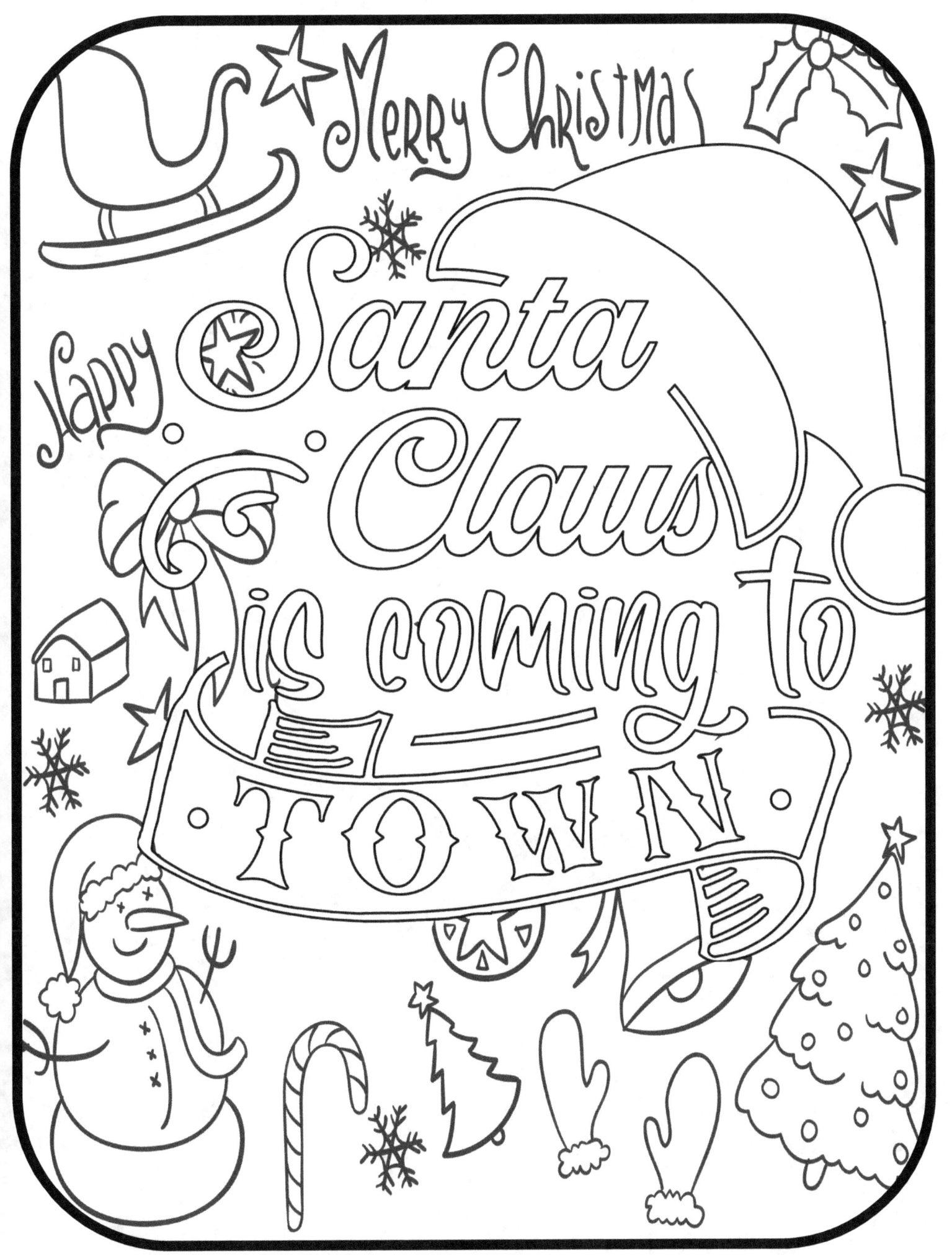

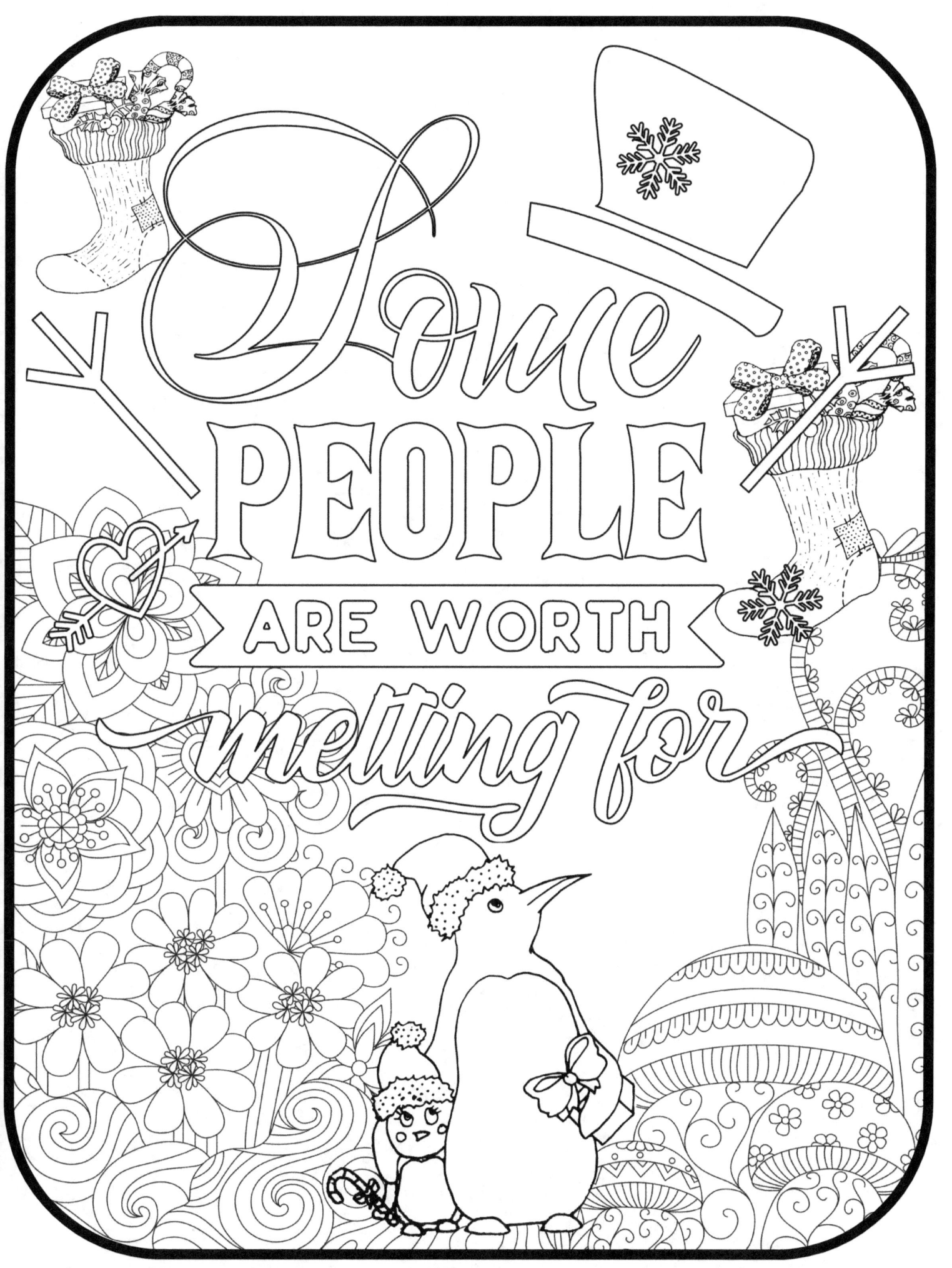

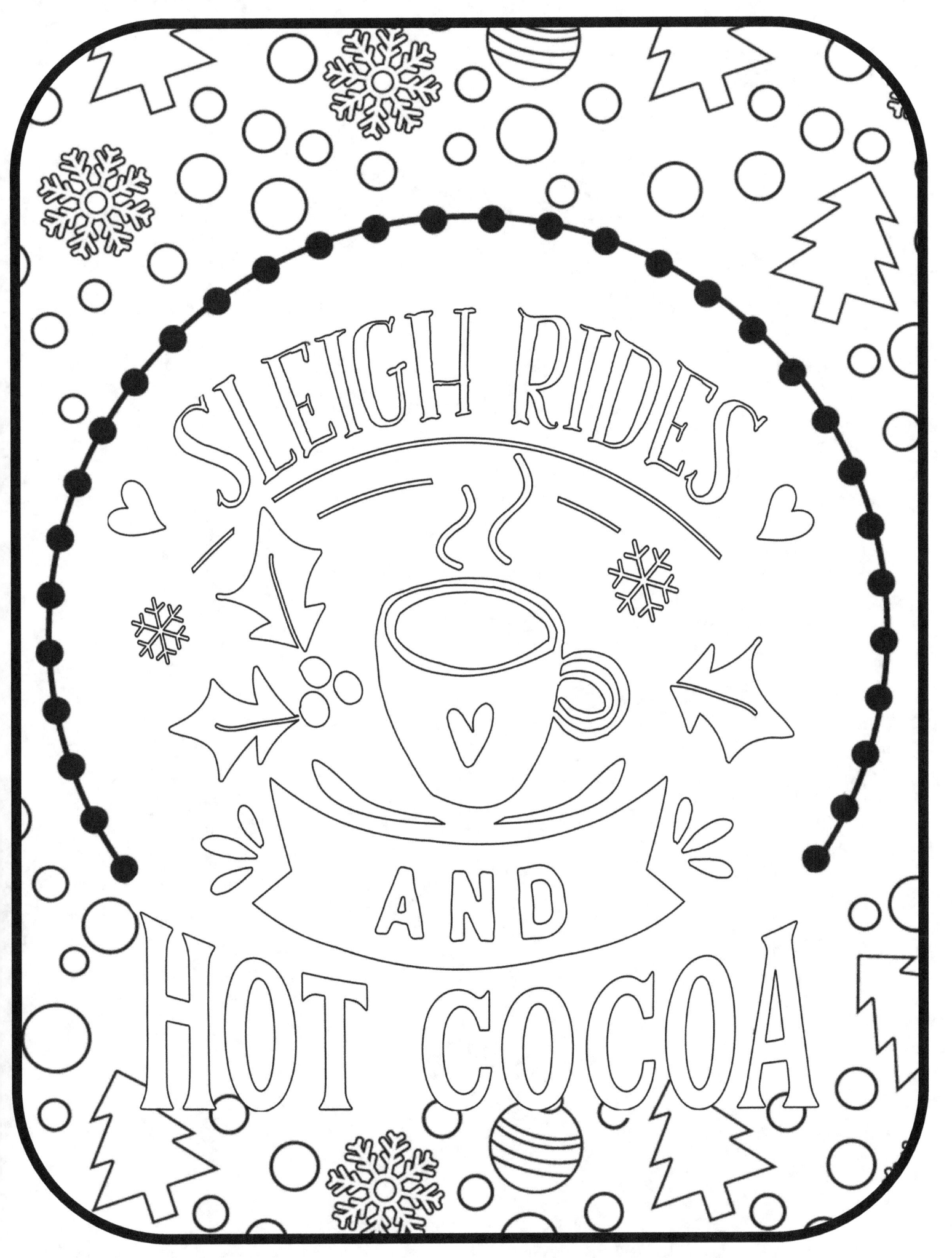

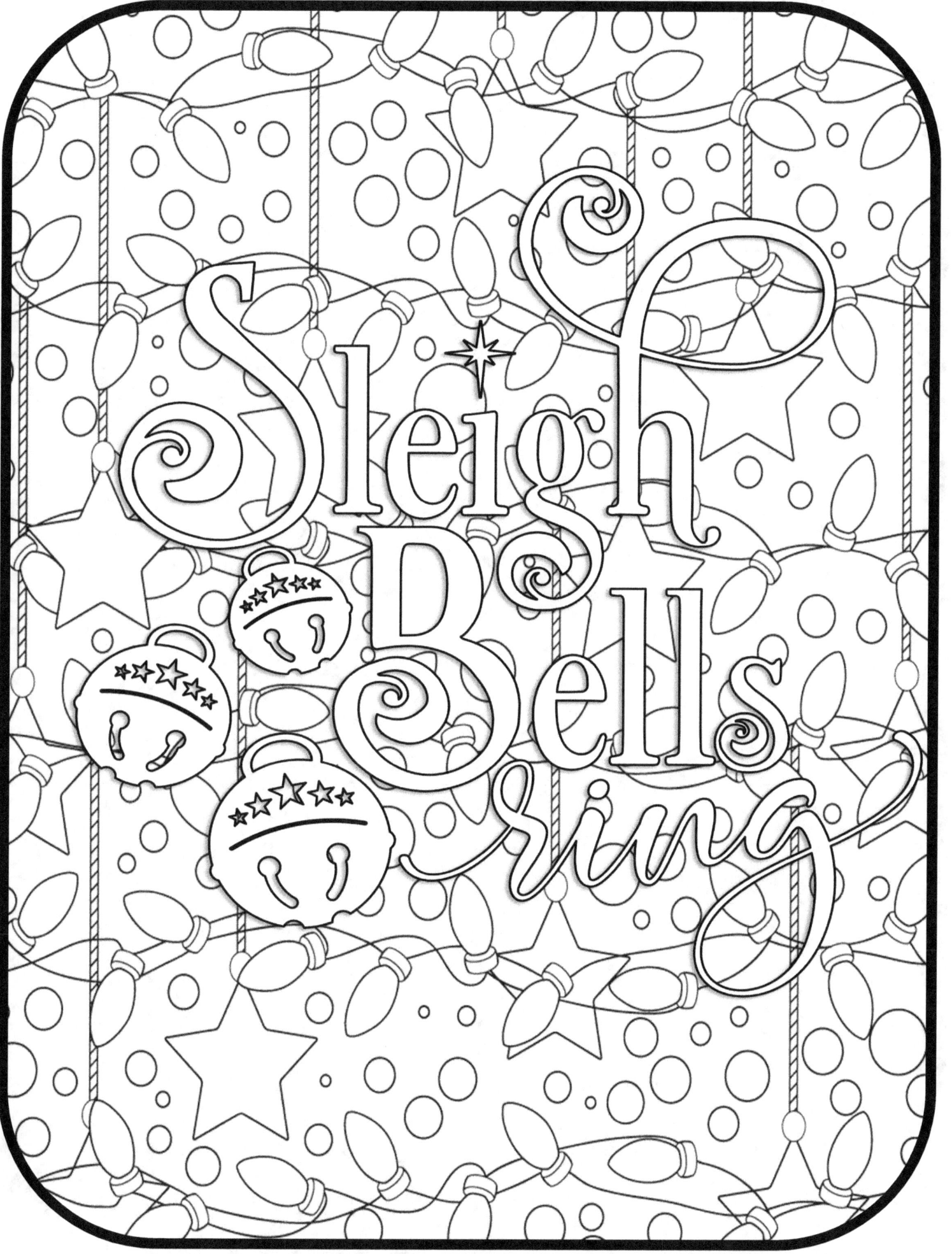

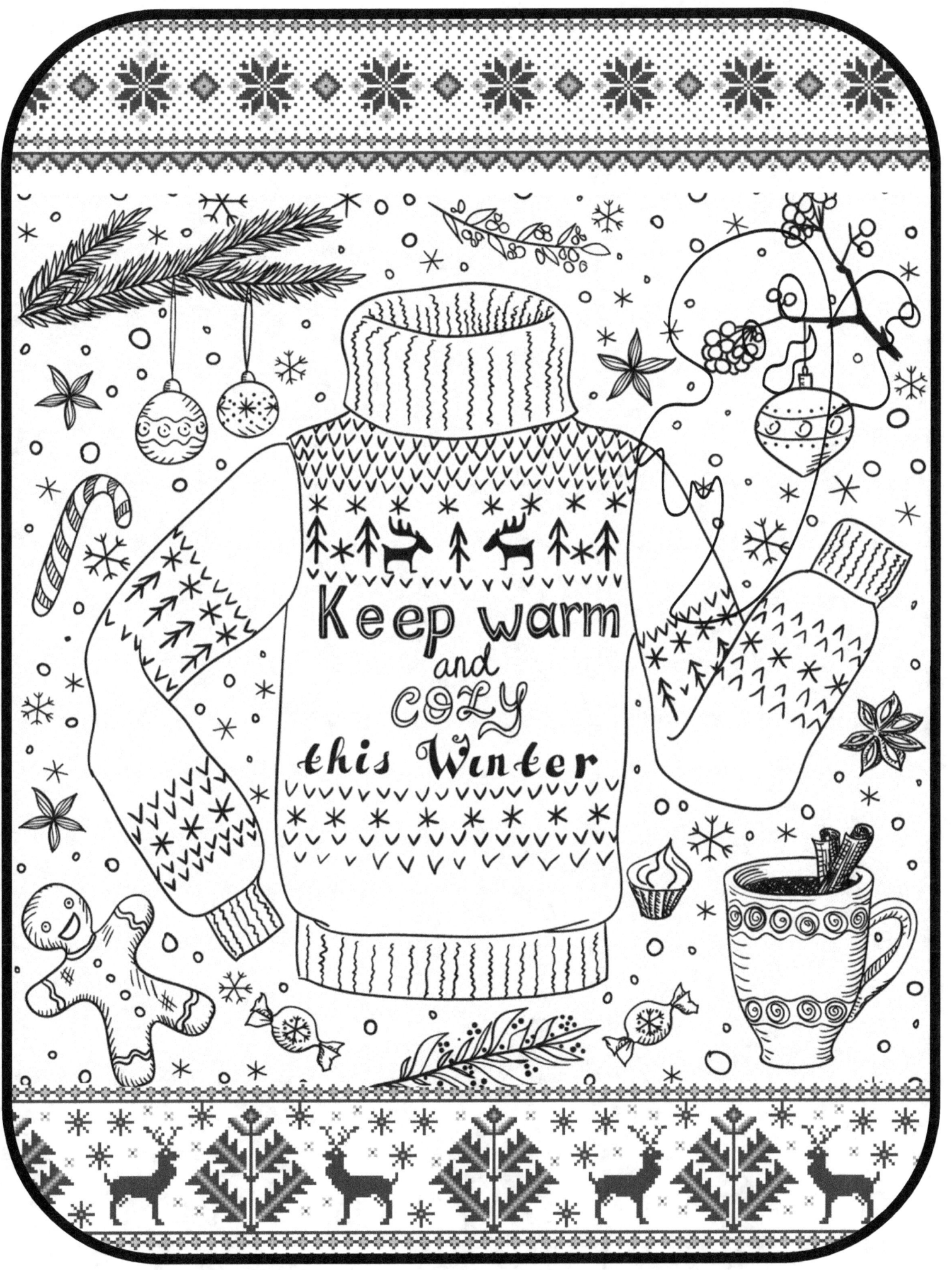

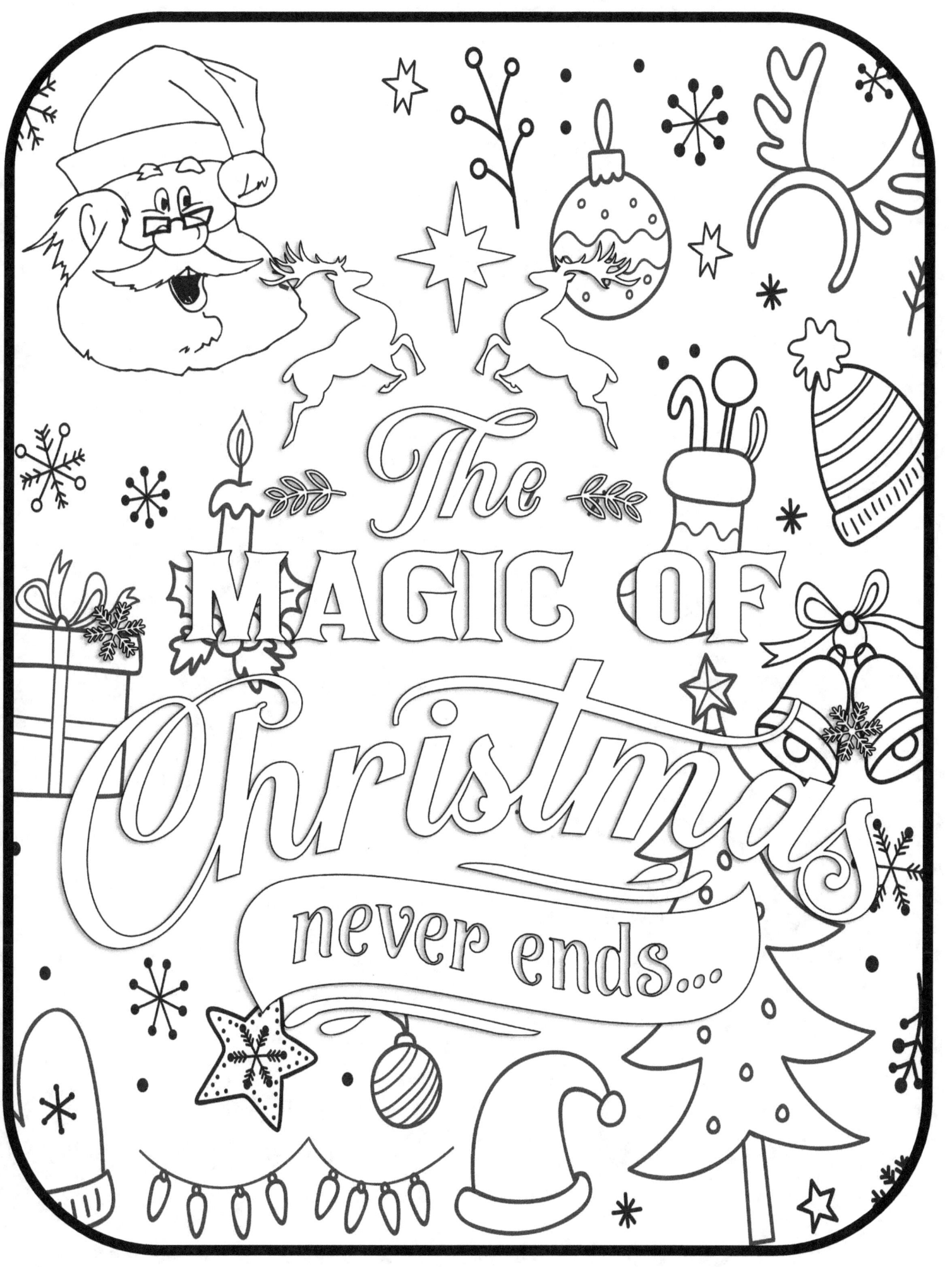

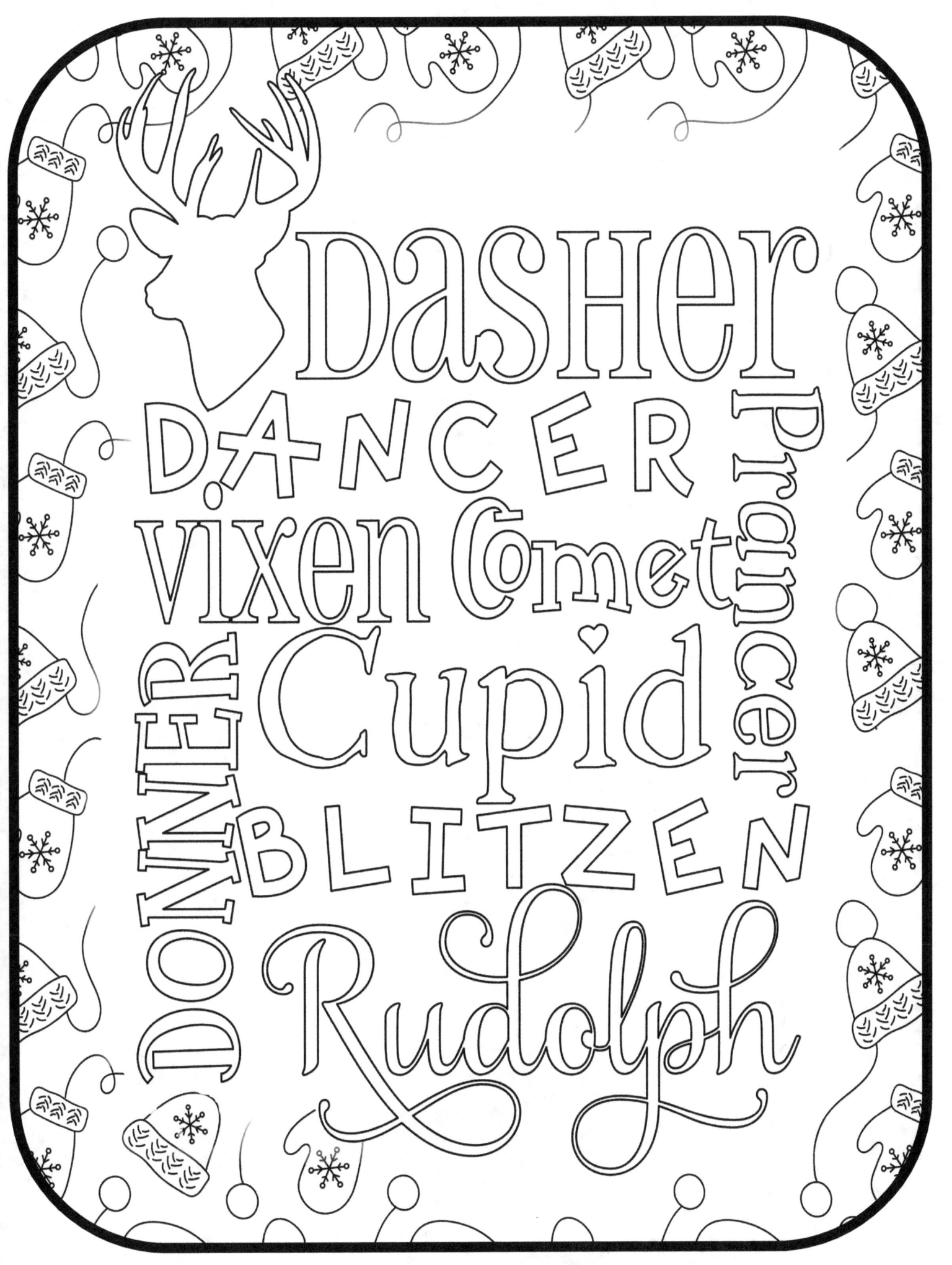

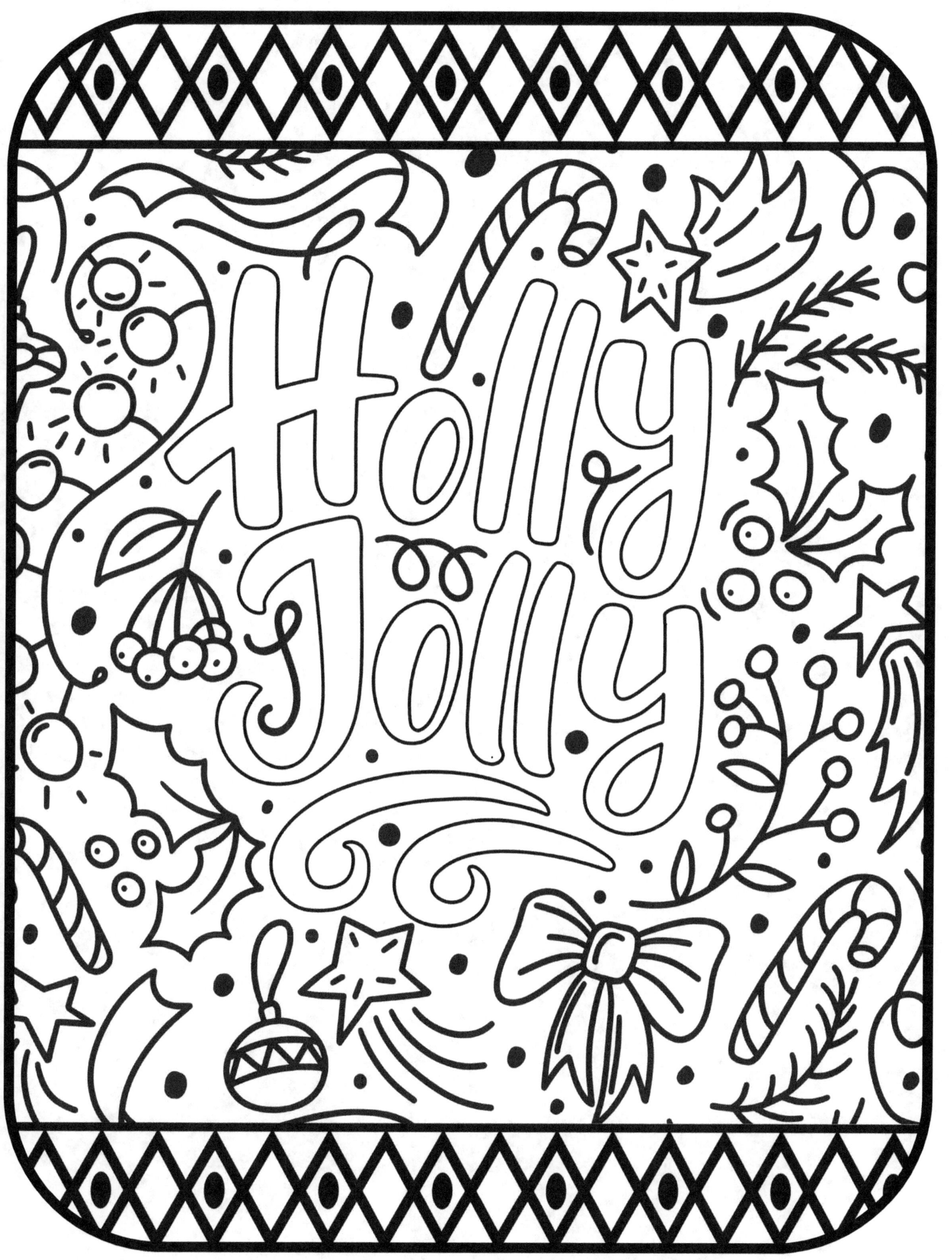

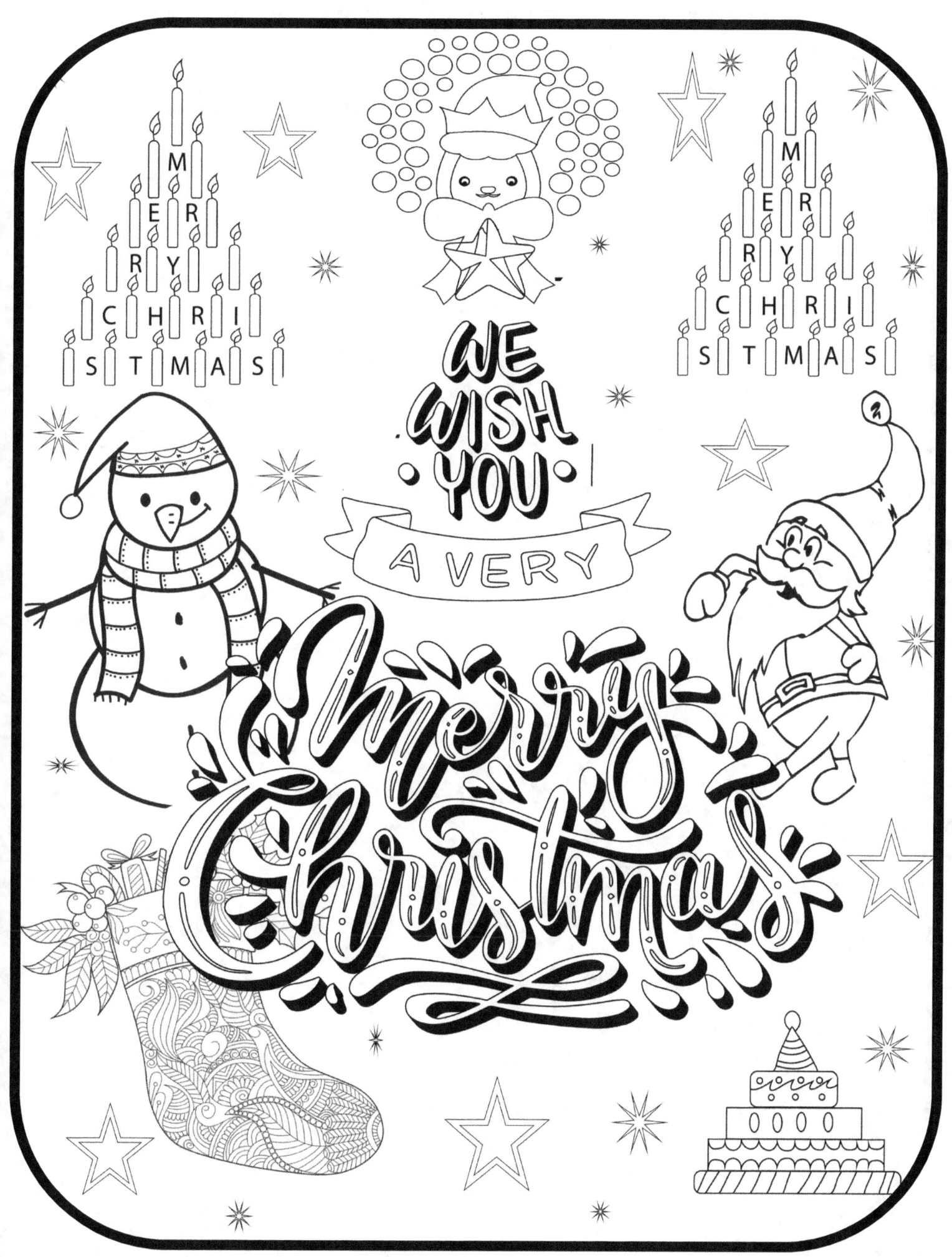

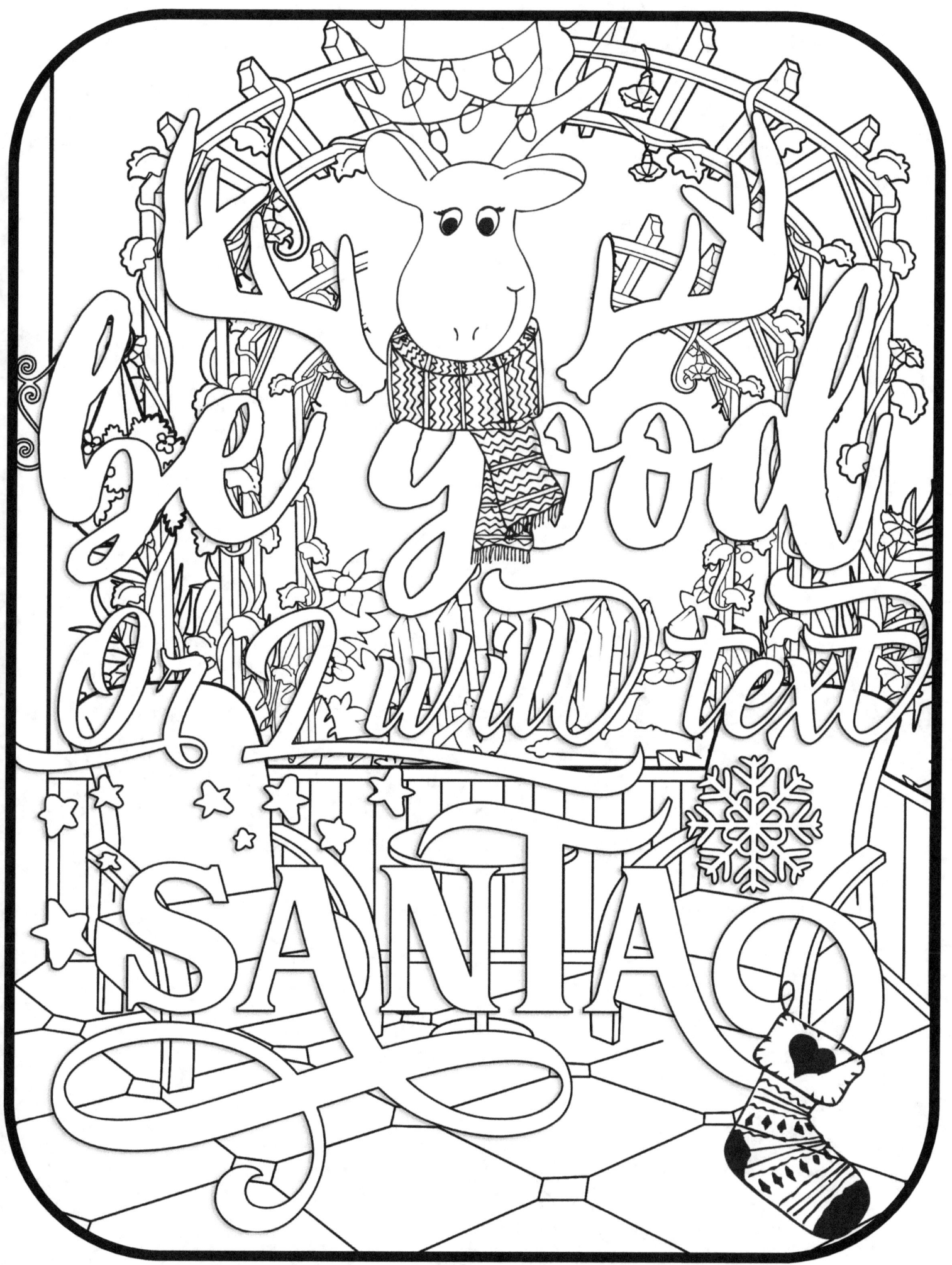

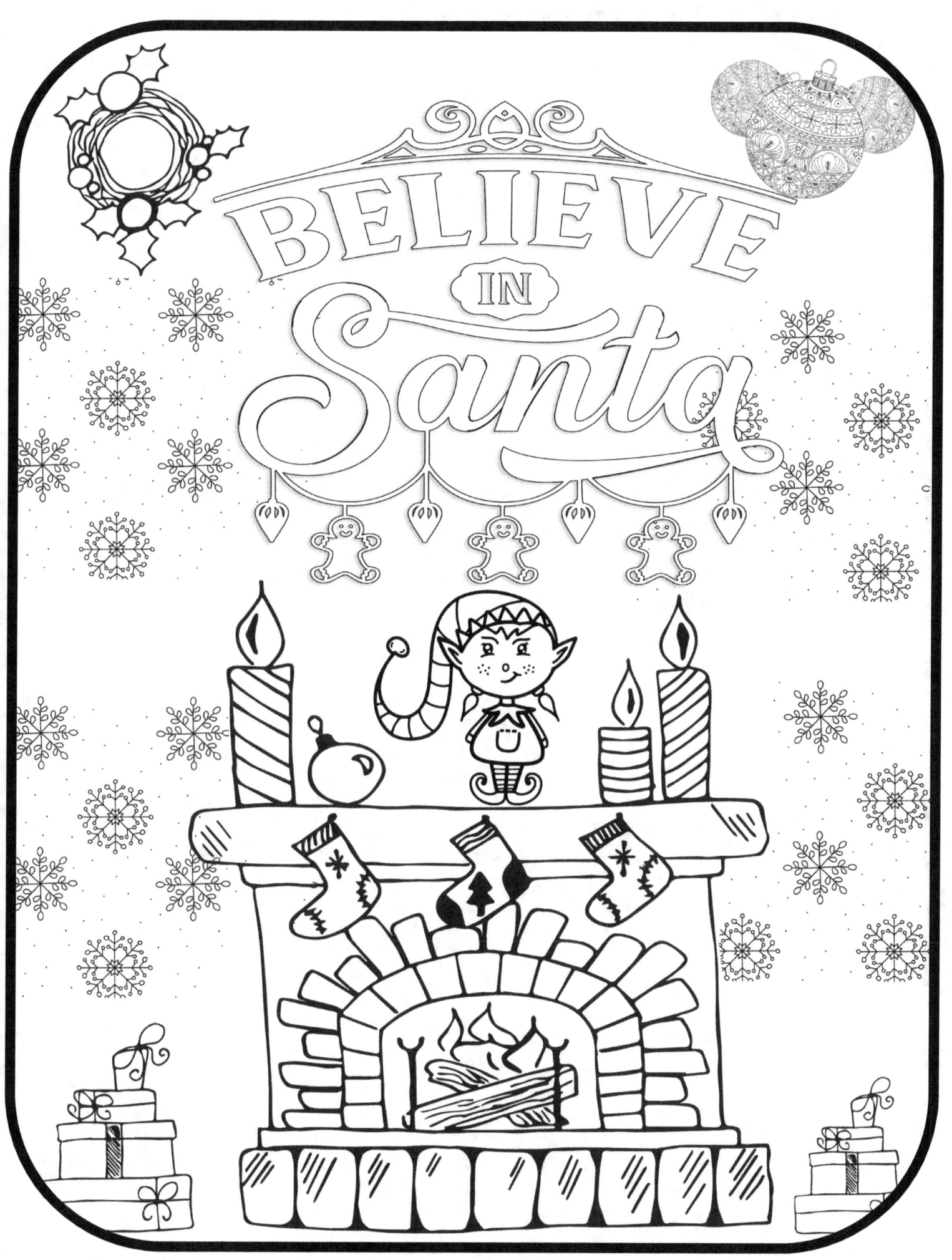

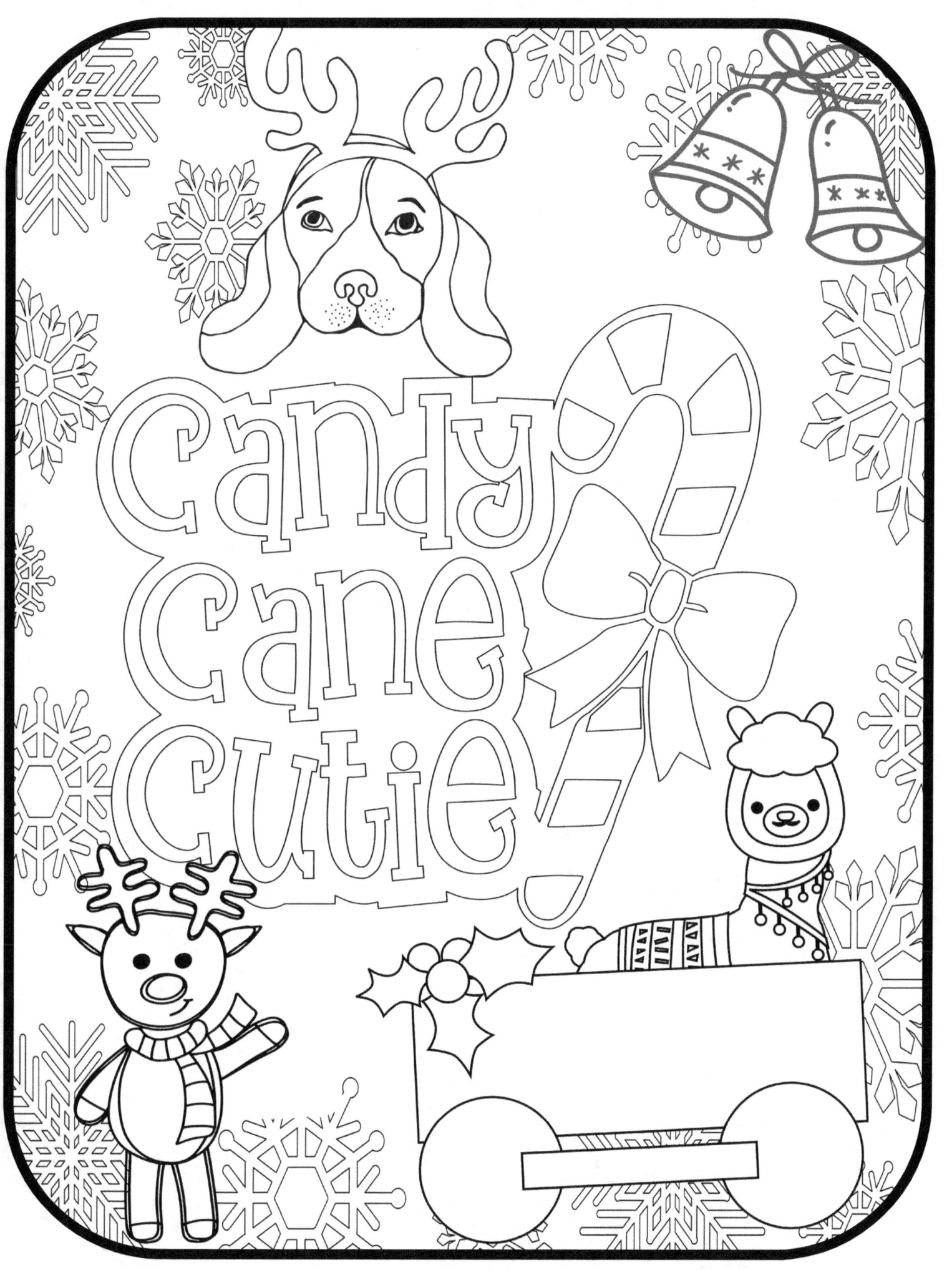

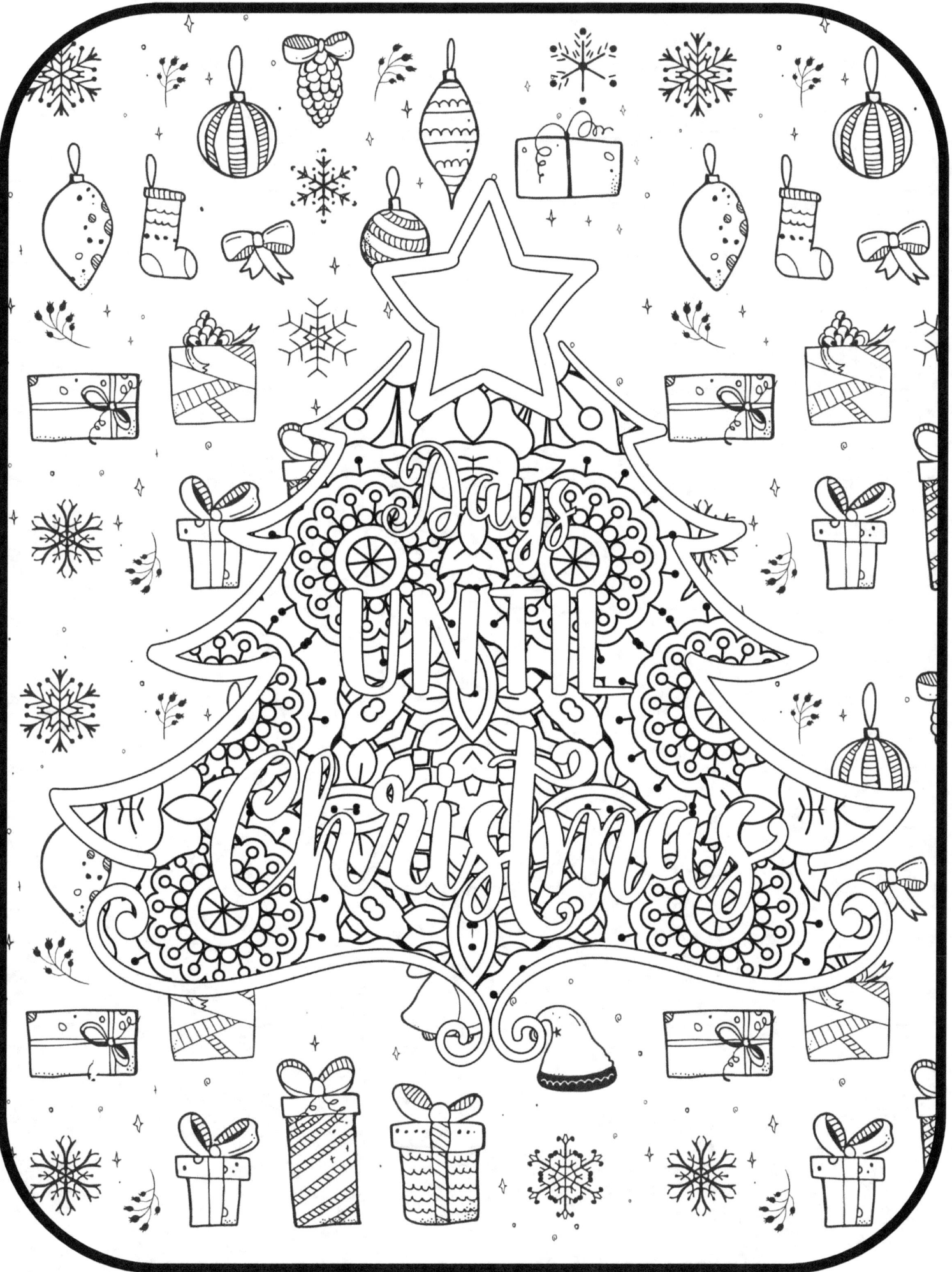

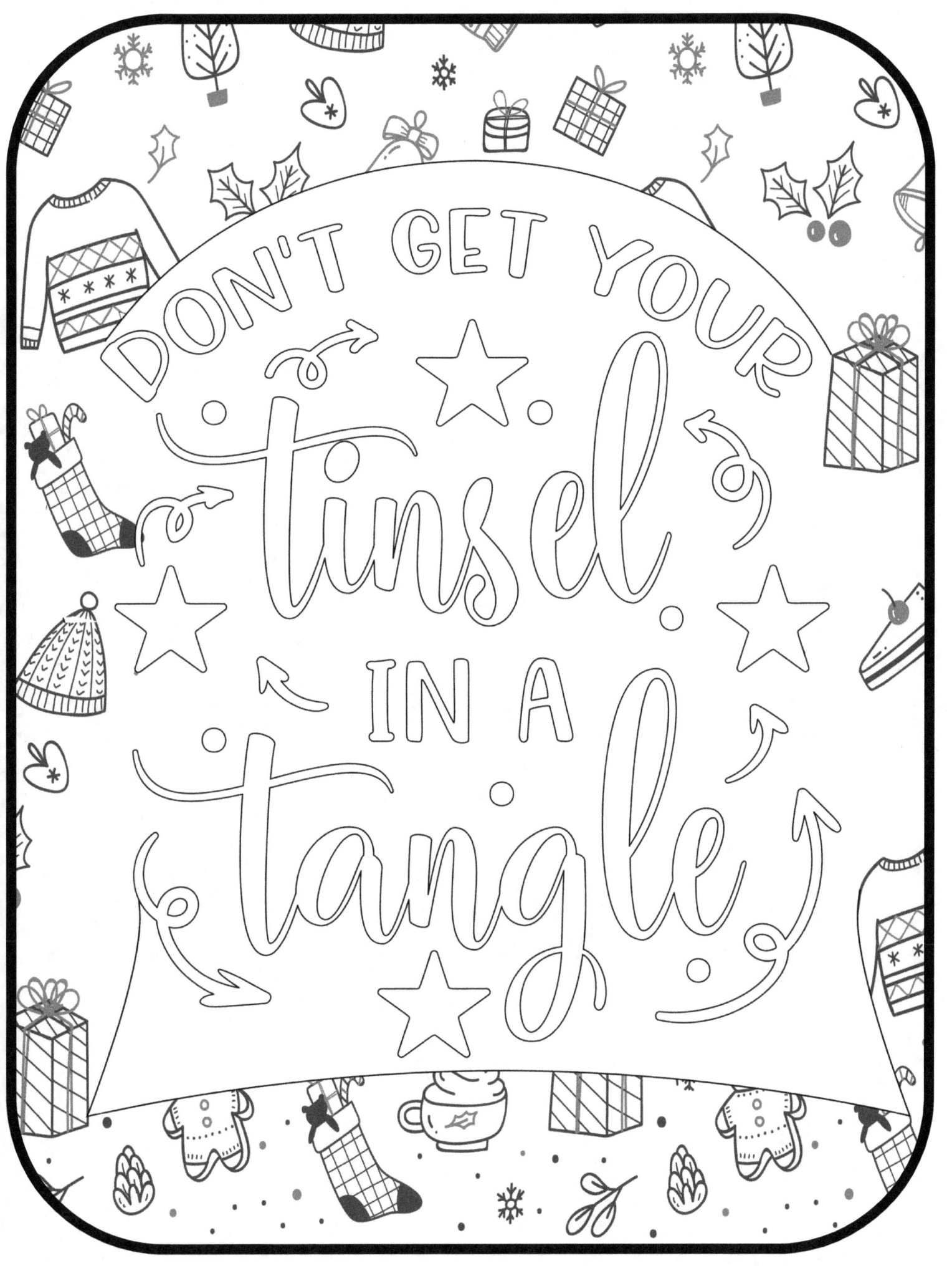

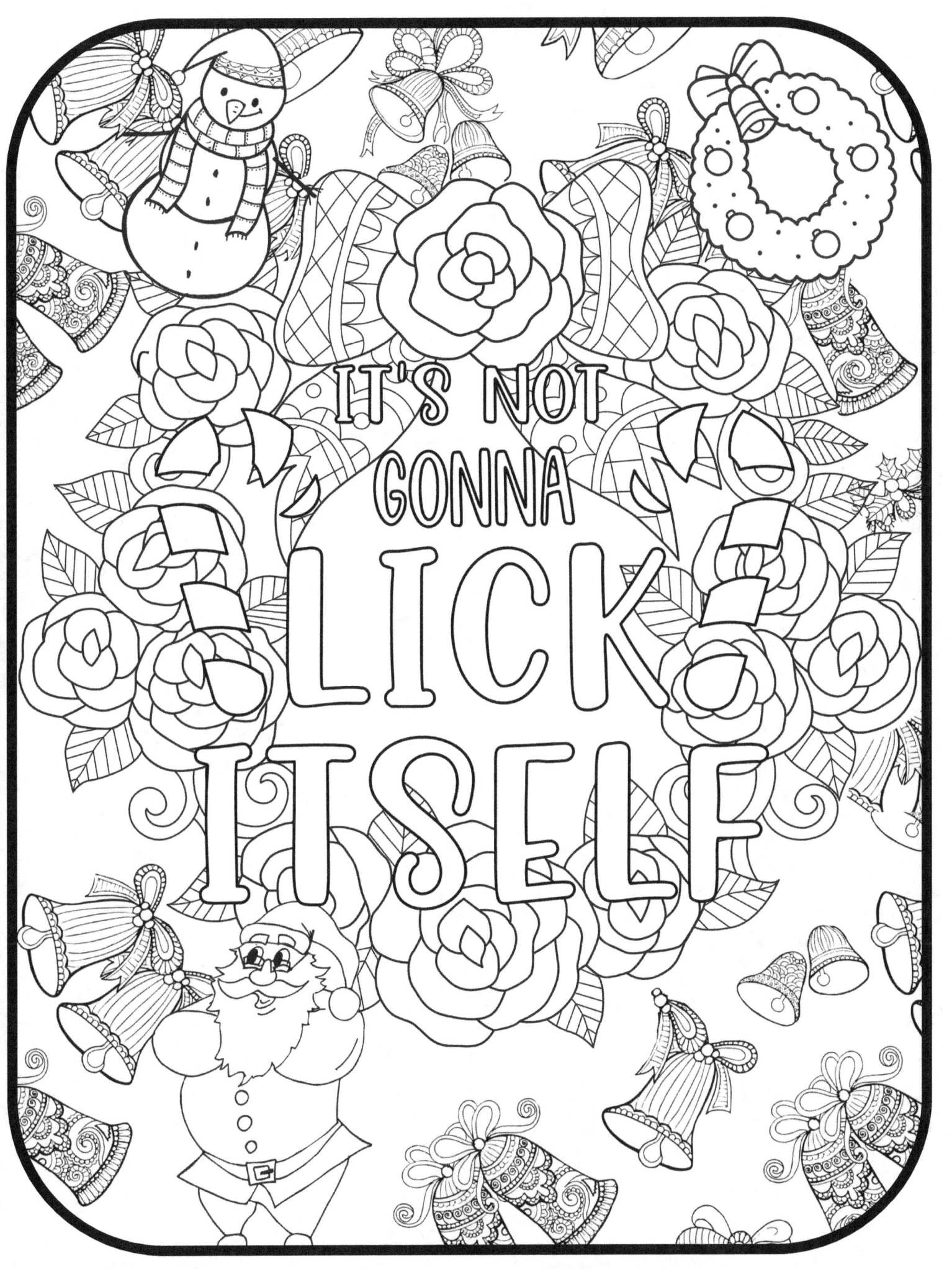

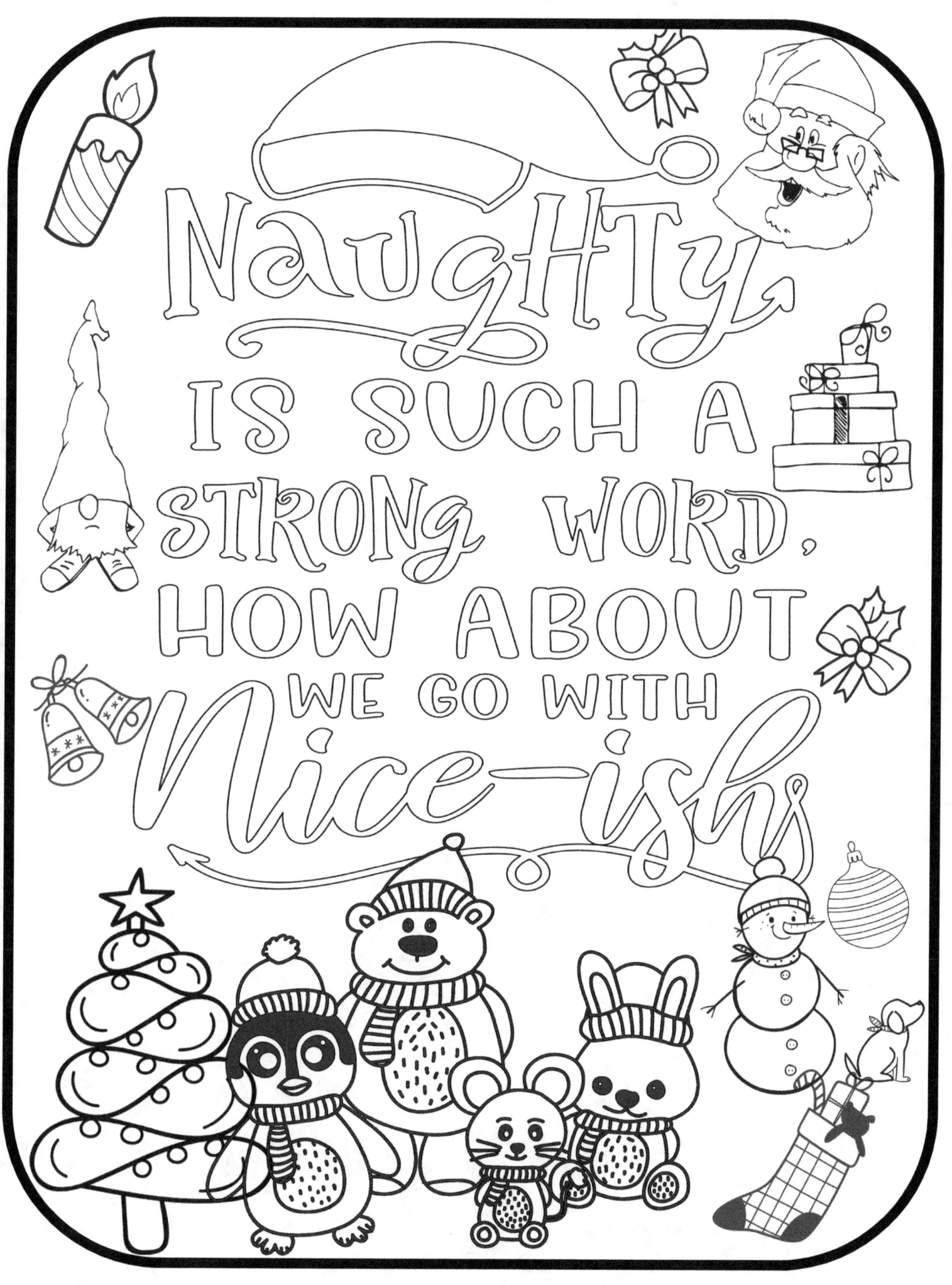

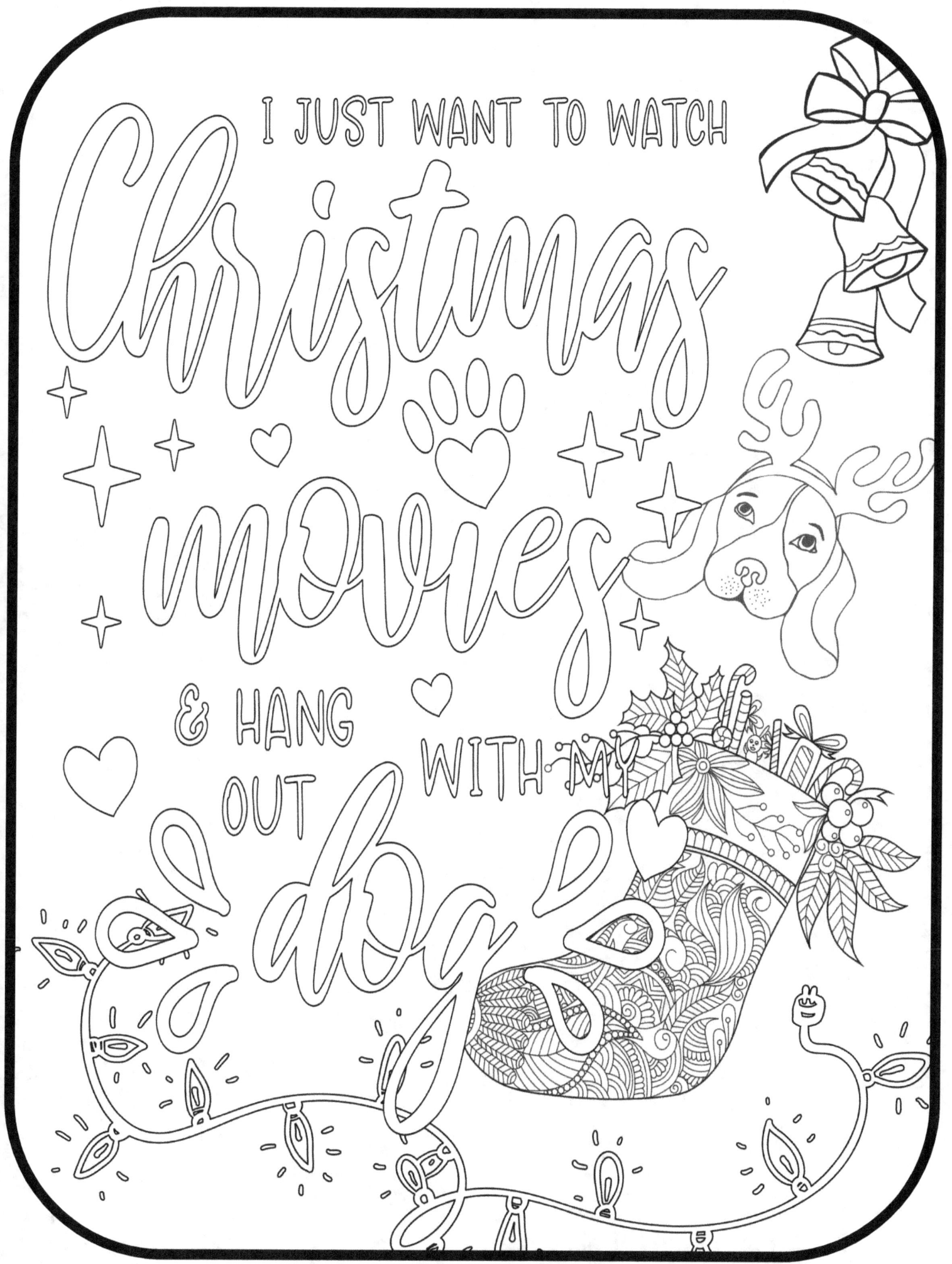

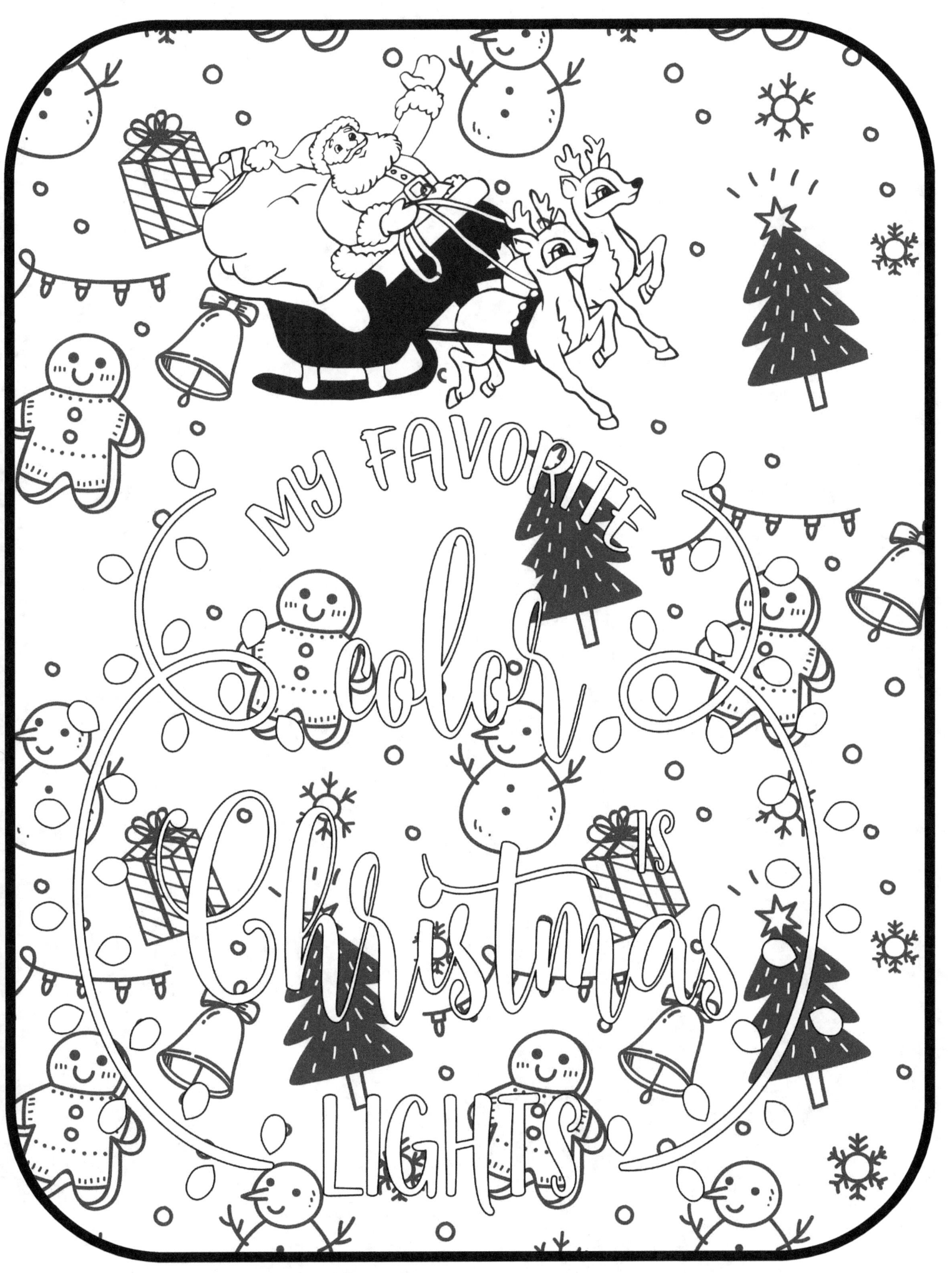

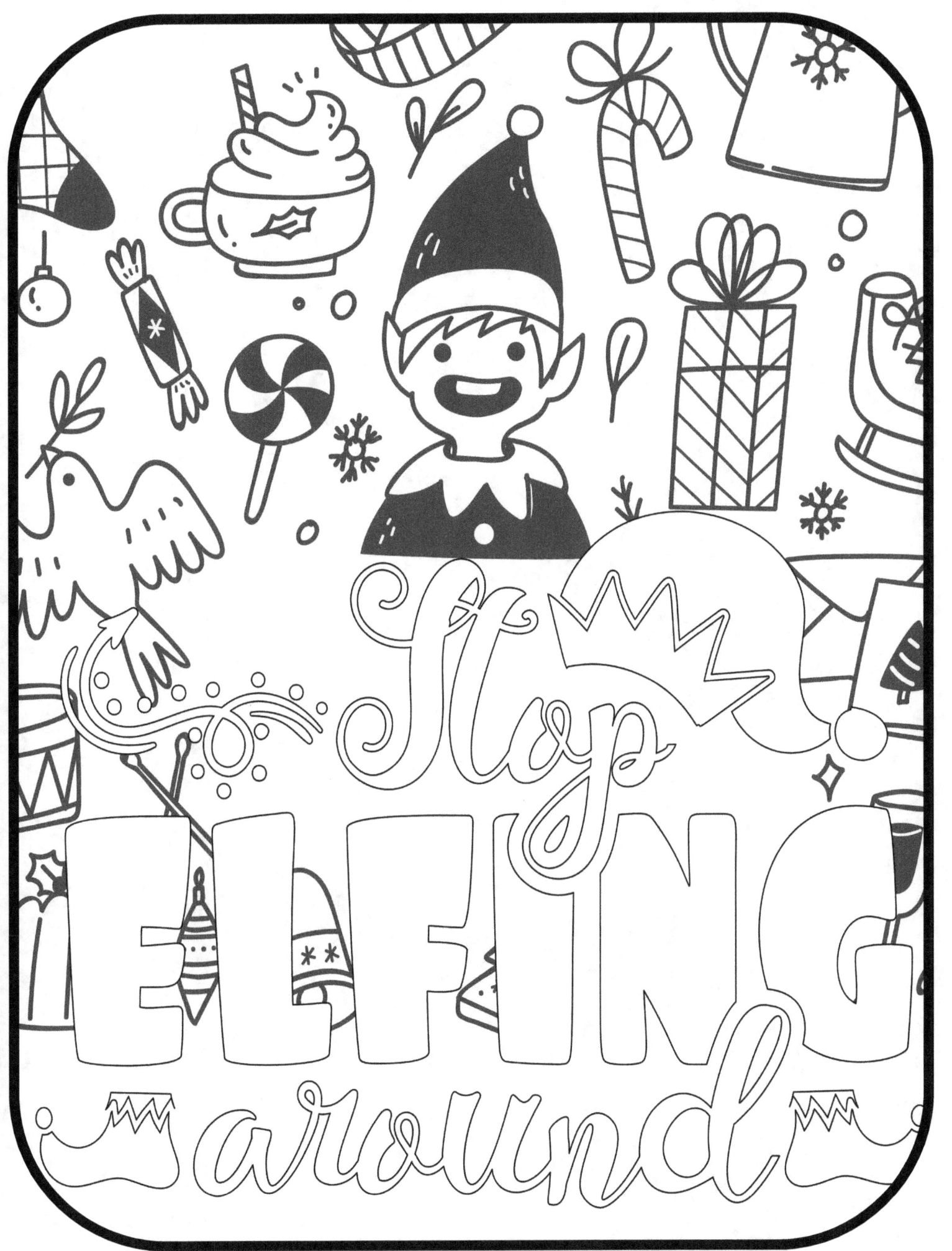

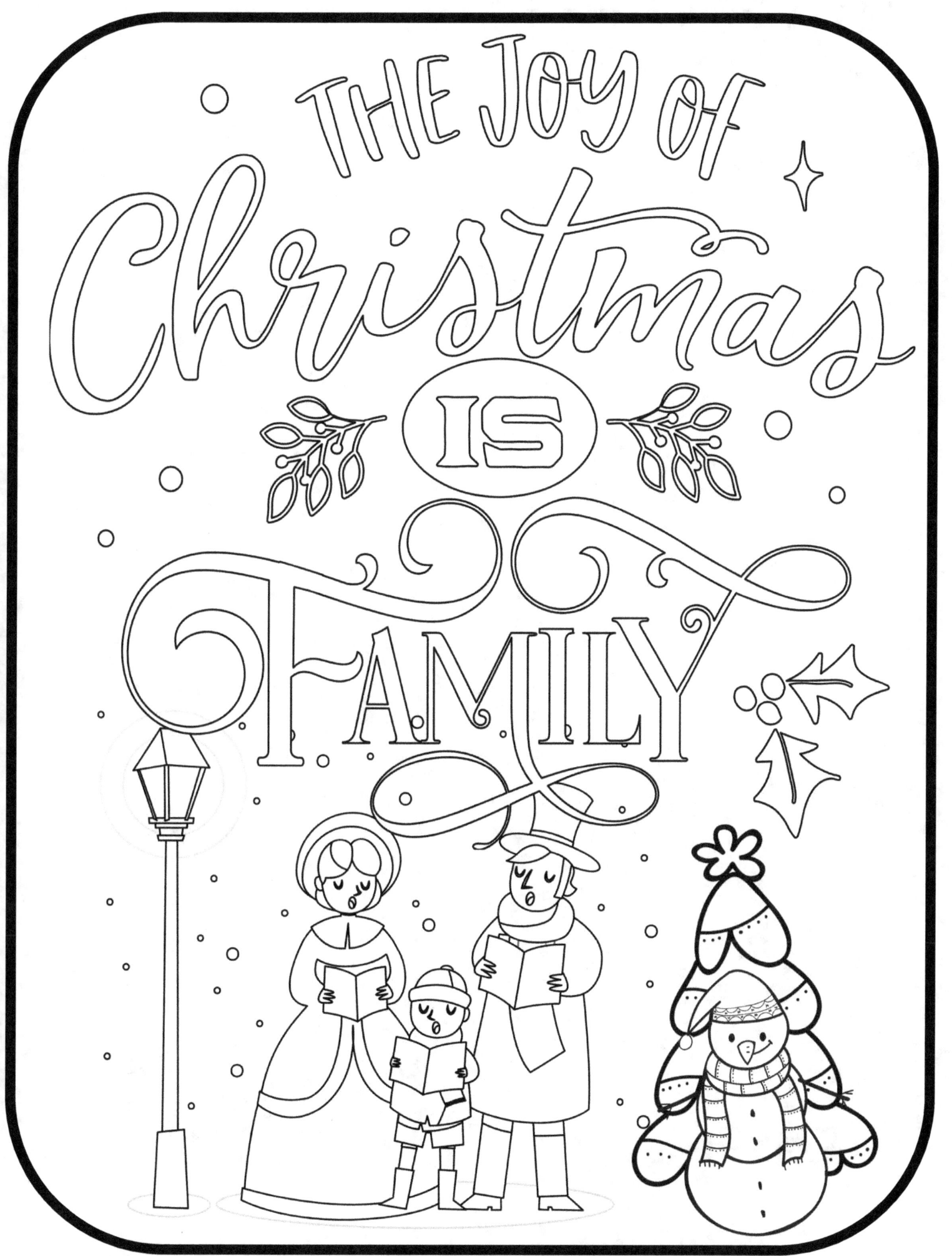

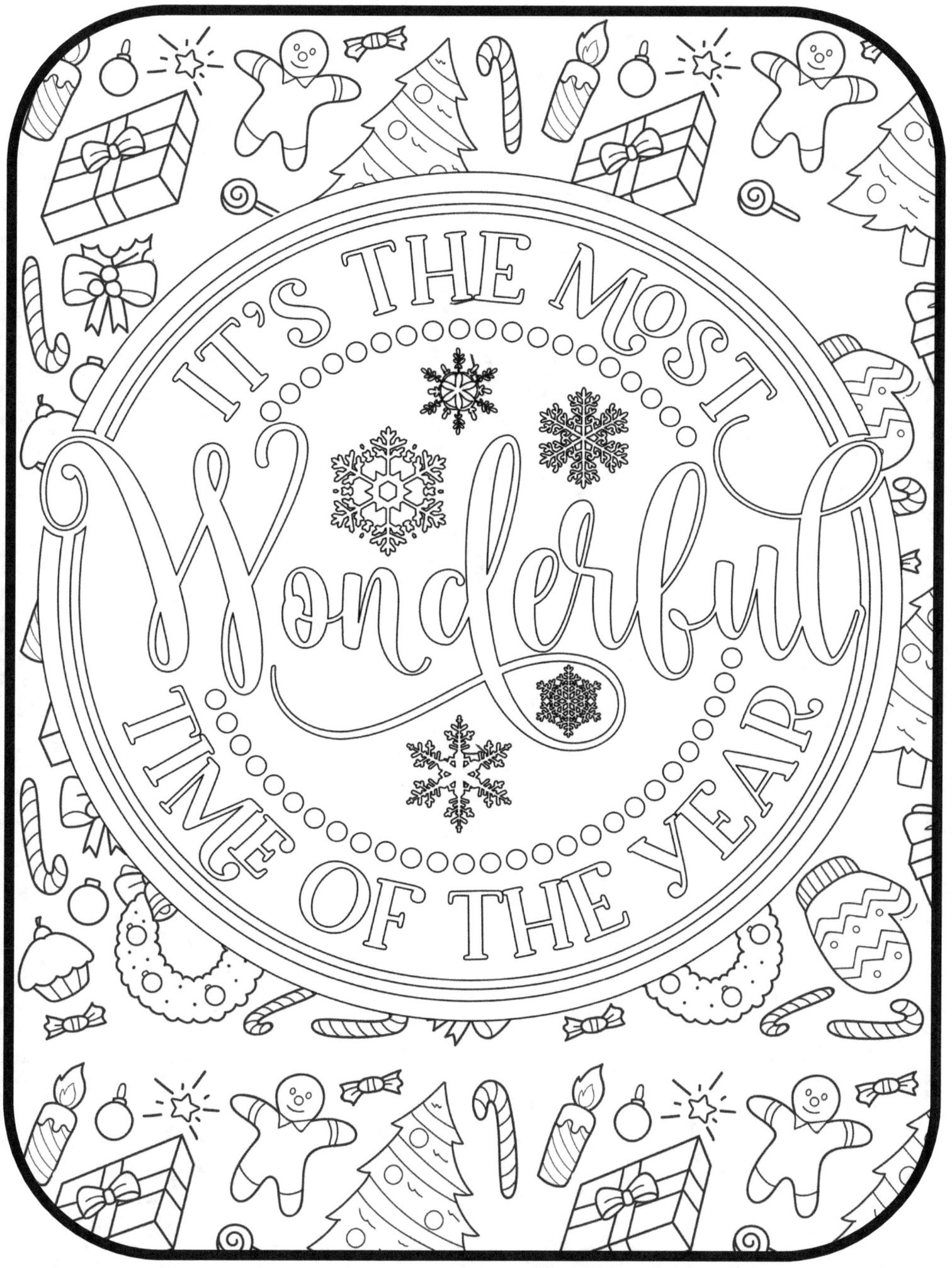

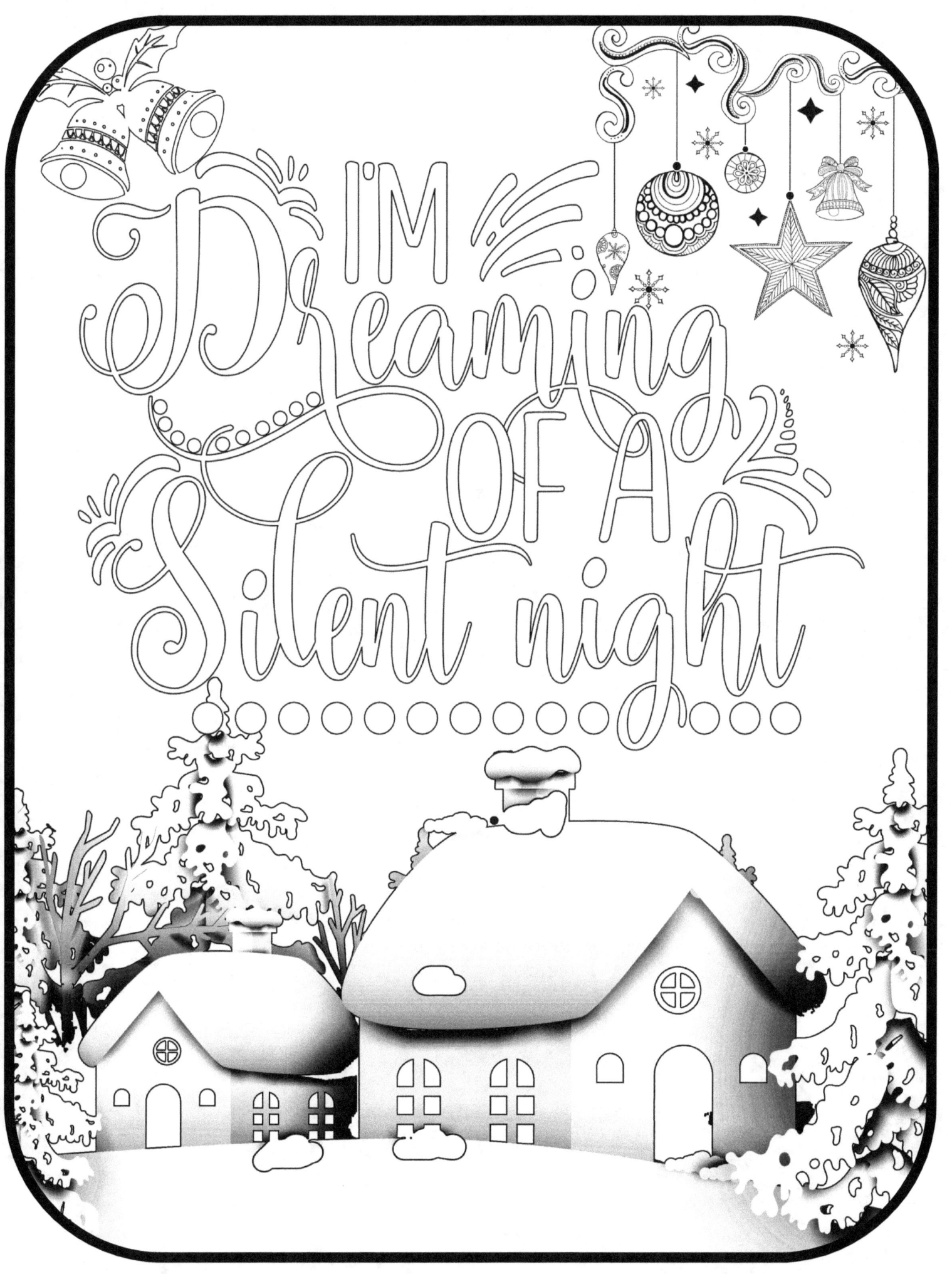

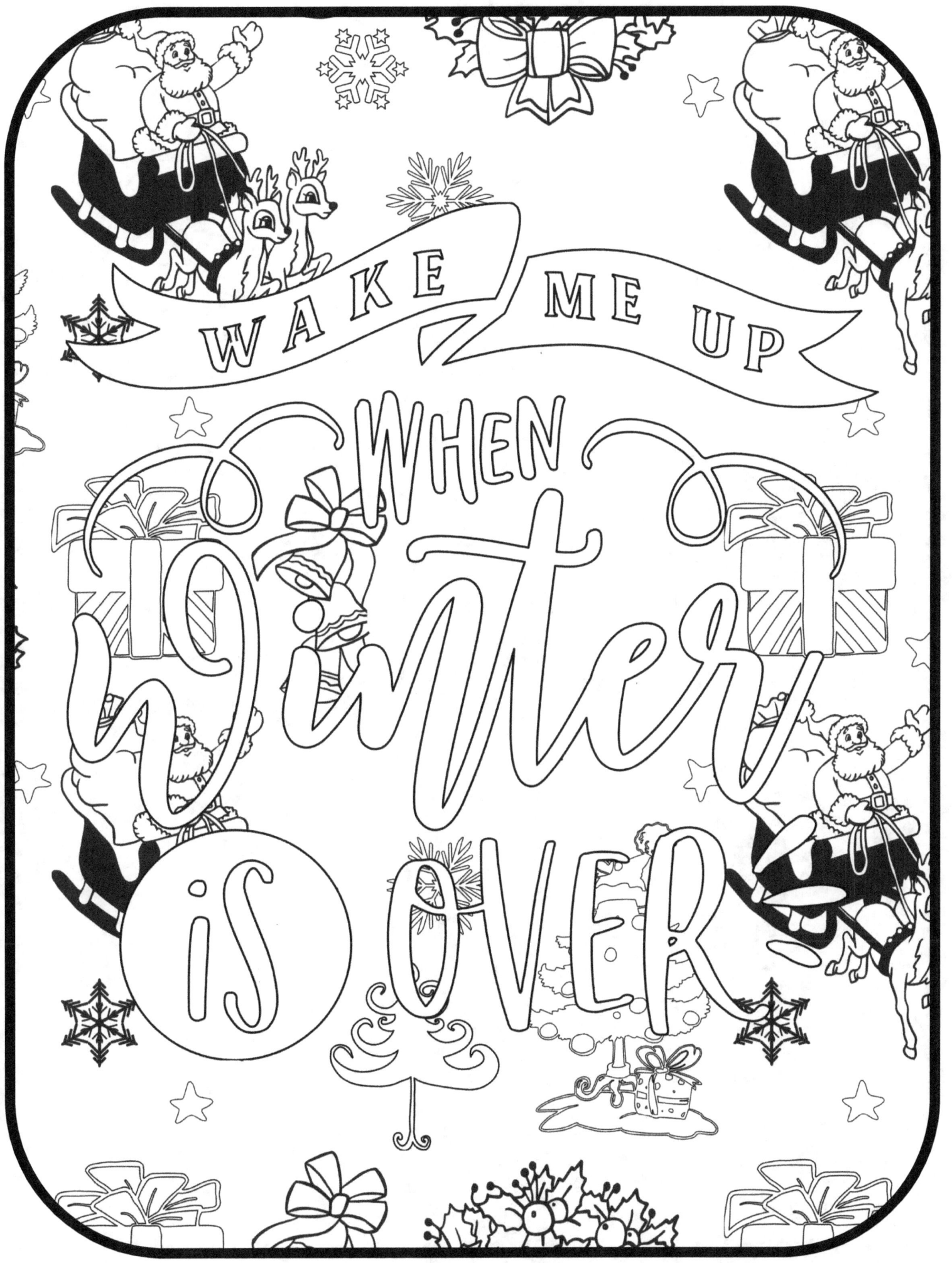

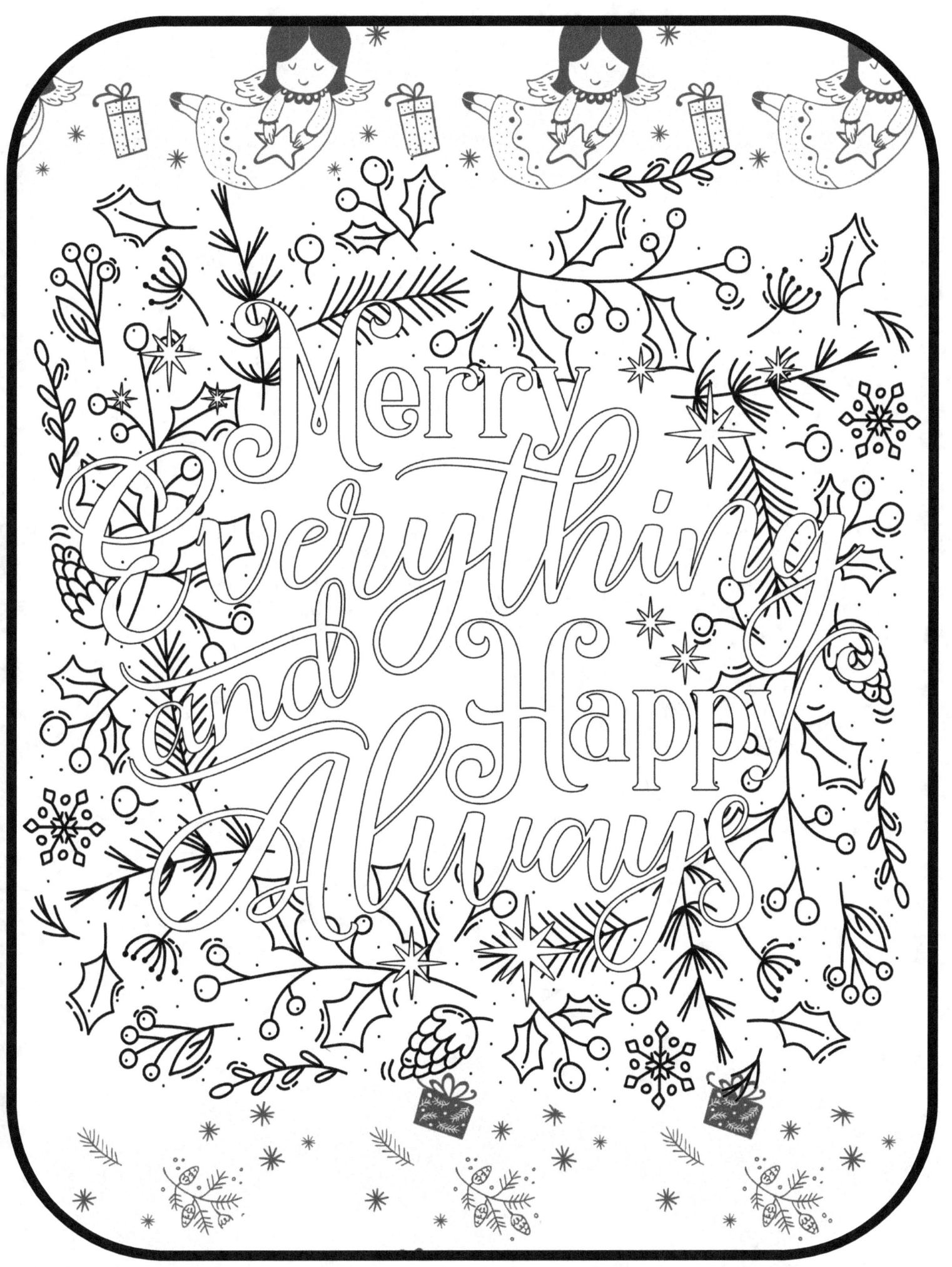

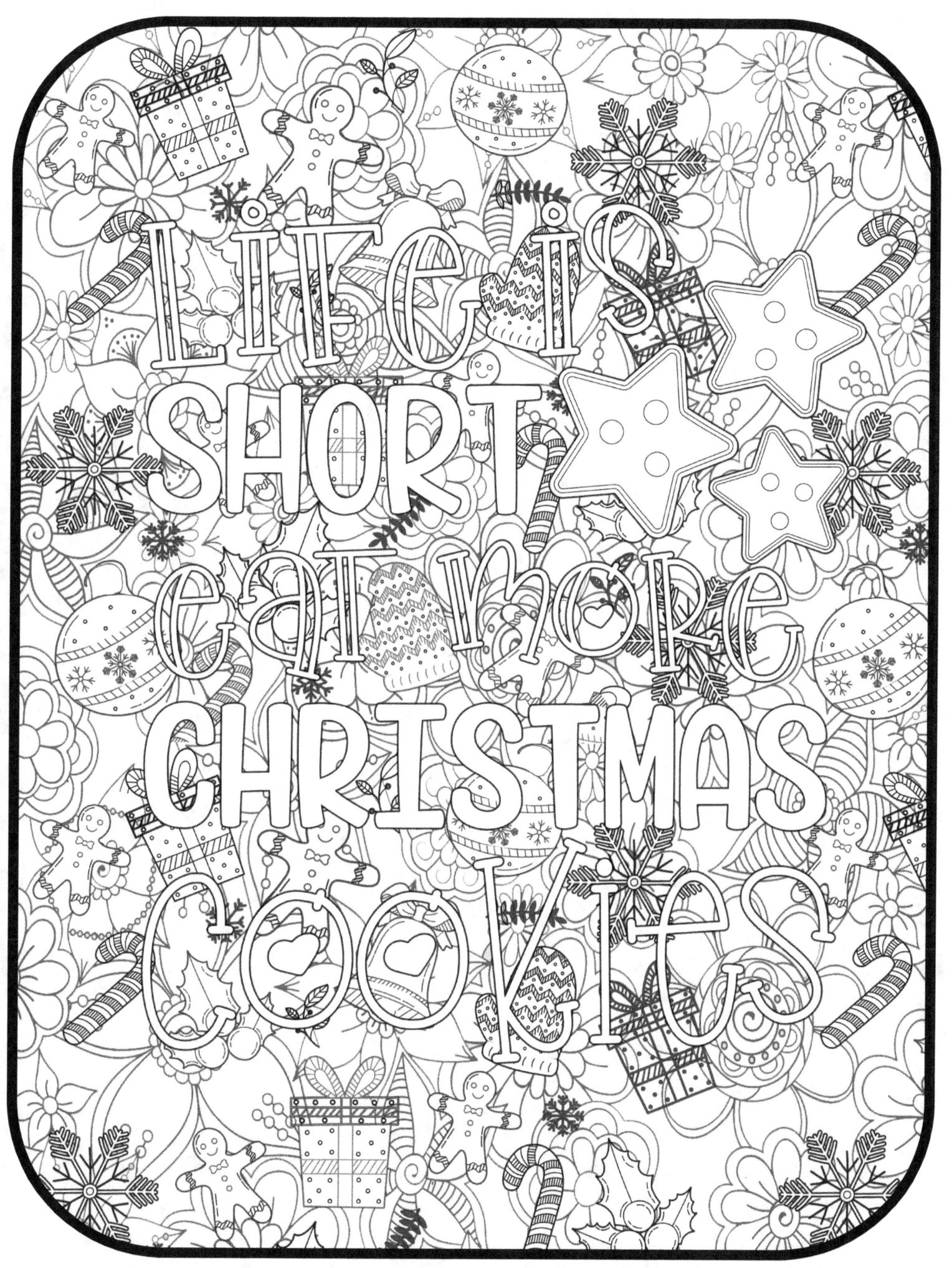

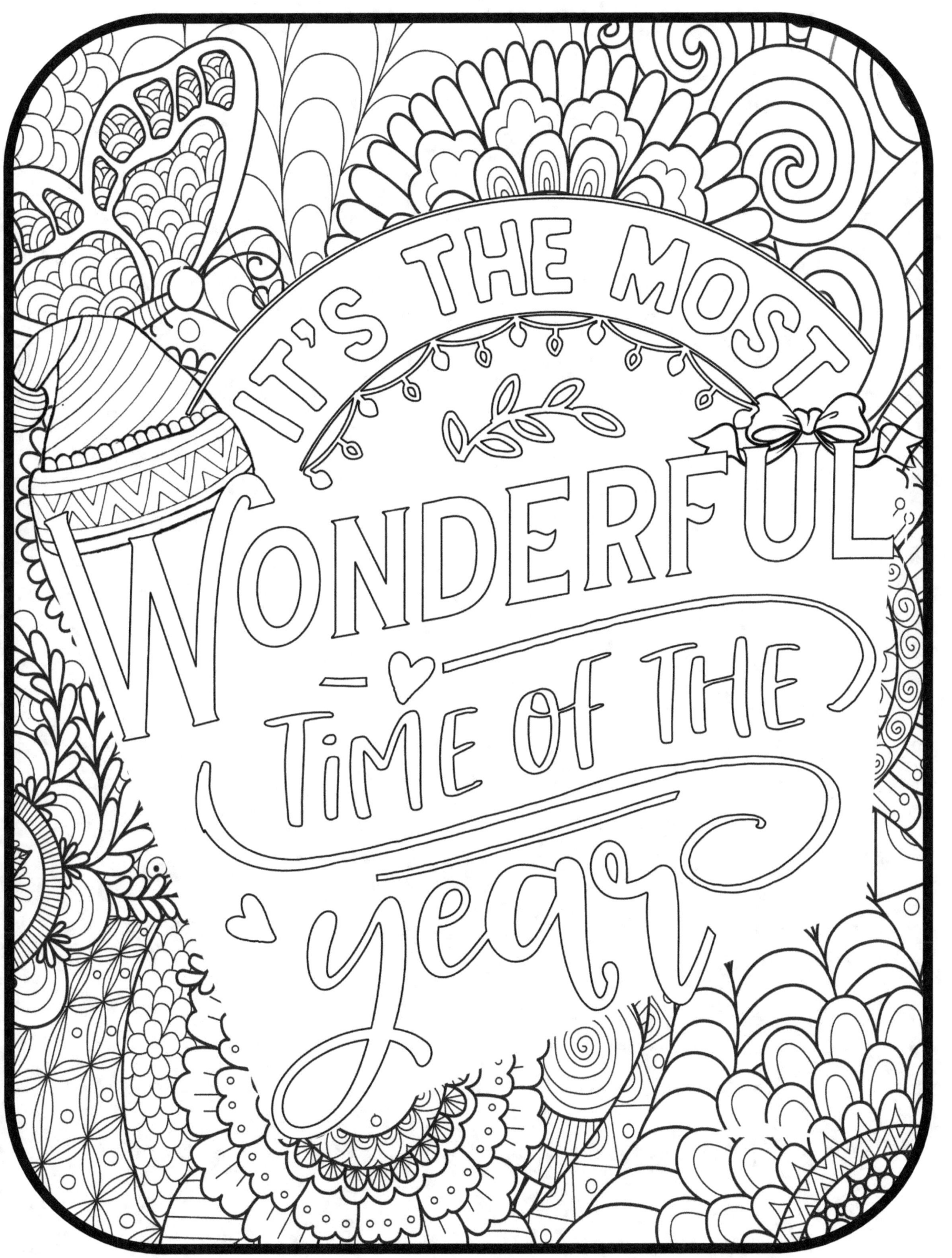

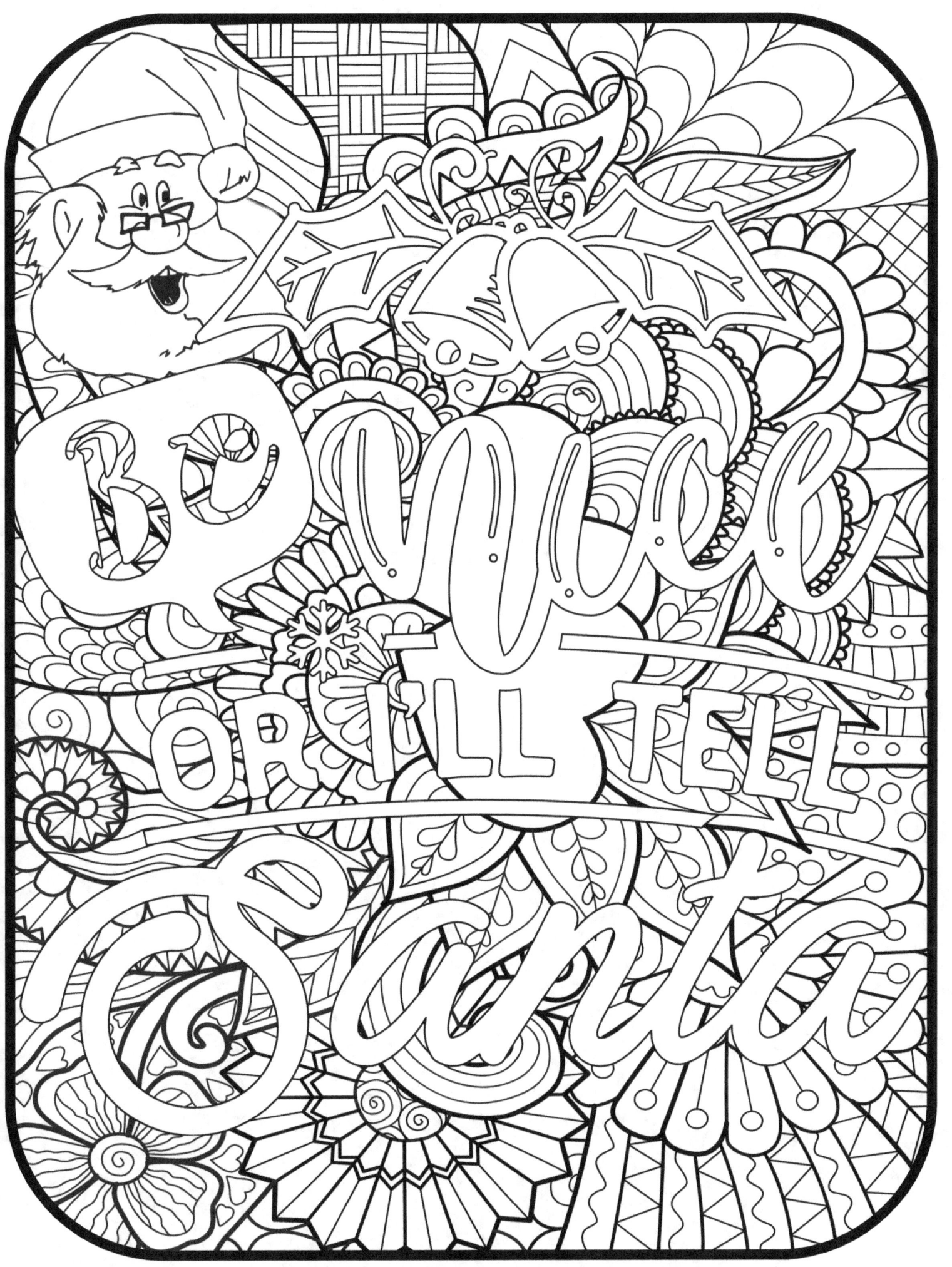

www.ingramcontent.com/pod-product-compliance
Lightning Source LLC
Chambersburg PA
CBHW081500220526
45466CB00008B/2728